Jane Austen's
Universal Truths

Jane Austen was born in 1775 and died in 1817. Her novels, in order of publication, are:

Sense and Sensibility (1811)
Pride and Prejudice (1813)
Mansfield Park (1814)
Emma (1816)
Northanger Abbey (1818)
Persuasion (1818)

A number of drafts and fragments, including the novel she was working on when she died, *Sanditon* (1825), were published posthumously.

Jane Austen's
Universal Truths
Wisdom & witticisms from her writing

Susan Hart-Byers

PORTICO

This book is dedicated to
the memory of Jane Austen,
and to all who have loved
her over the years.

Contents

Introduction

Becoming a Jane Austen fan is rather like undergoing a religious conversion – you can resist for a long time but in the end her power is too great. As a child growing up in the bush in Australia I read everything I could, except for Jane Austen, after reading an abridged version of *Pride and Prejudice* at school. Boring. Long, hard-to-follow sentences, silly characters, tame plots, all the books the same – a world far away from mine in every respect. Who would bother?

Years later, travelling around Europe with a friend, held up in Germany by a vehicle in need of repairs, bored, unable to speak the language, with nothing to read, I was given a copy of *Emma*. I grabbed it as a lifeline – a long book, in English – just what I needed. It wouldn't have mattered what it was – even a car manual would have been fine.

I began reading, hoping only to fill in some time, and was immediately entranced. Before I had finished the first couple of pages I suddenly saw the point. It was like all the clichés – a key turning in a lock, a light switching on. I knew I had found a source of pleasure, comfort and mental stimulation that would last all my life.

Over the years I came to know and love them all: clever Emma and the wonderful Mr Knightley in *Emma*, funny little Catherine Morland in *Northanger Abbey*, stoic Elinor Dashwood in *Sense and Sensibility*, silly Mrs Bennet and Miss Bates and Mrs Jennings and all the other comic characters, and my favourite of all, dear Anne Elliot from *Persuasion*.

Of course I wasn't the first to fall in love with her books, but I felt as if I was, and wanted to share my discovery with anyone who would

listen. I didn't make a lot of converts, but it was always wonderful when I met a fellow believer.

Now, due to film and television adaptations, half the population seems to be reading her novels while the other half ponder the reasons for her popularity. Is it because she is so amazingly, bitingly, bitchily funny? Is it the clever plots? The wonderful characters? Do people love the happy endings? Is it the illusion of escaping to what is considered a more gentle and simple age?

Probably much of her current popularity is due to the humour, which exactly suits our cynical age, but more important than anything else is the fact that Jane Austen sympathized with the human condition. She successfully made fun of human foibles because she understood people so well. It is sometimes suggested that Jane Austen didn't like humankind, but I disagree. She was amused by observing others, and often irritated – aren't we all? – but never cruel. We may also find, despite our cynicism, comfort in Jane Austen's orderly world, that perhaps what we truly want is a sense of direction. We appreciate the moral stance that underlies Austen's irony.

Our response to Austen changes with age. When we are young we read her for the romance. As we mature we read her for the wit. Older again, we sense the depth of feeling in her work. After all, the reason we re-read great literature is because we find something new in it every time.

As well, the great writers tell stories that appear true to life, set in a particular place and time, and yet demonstrate for us the universal, the timeless. For instance, I can read what Jane Austen had to say about the countryside and identify with the sentiments exactly – even though her countryside was green and soft and misty and mine

was hot and harsh and pale. That was part of Austen's genius, and the reason that she is still enjoyed today, over 200 years after she died, and by people all over the world.

I have chosen these quotations to show that the ability of Jane Austen's fiction to find resonance in lives far removed from her own is evidence of a deep truth – that human nature doesn't change. Attitudes and values alter over time, the external world becomes ever more technical, but people are the same. In Austen's observations you will recognize your friends and relations; you will recognize emotions and thoughts that have occurred to you. It is strangely comforting to feel this affinity with people from another time. Life hasn't altered as much as we sometimes fear – the essentials remain the same.

To demonstrate this universality, I have not attributed the sayings to a particular speaker, but left them in isolation, indicating only from which novel they came. However, I suspect those who know the novels well will probably find themselves unable to resist the temptation to test themselves on their knowledge. 'Now who was it who said that...?'

I have taken quotations only from the six famous novels: *Emma*, *Pride and Prejudice*, *Sense and Sensibility*, *Persuasion*, *Mansfield Park* and *Northanger Abbey*. Other material was available, of course – her letters, early writings, and the unfinished novels, *Sanditon* and *The Watsons*, but these six are not only her best-known, they are her best.

I had tremendous fun selecting these sayings. It was like a treasure hunt, like mushroom picking, like searching the sales for a bargain. I couldn't stop. I always had to do one more page, one more chapter, wondering what little piece of wisdom I would come across next. The quotations can be read to tell us more about Jane Austen's writings; or

to tell us more about Jane Austen herself, that private person always so tantalizingly out of our reach; above all, they can be read to tell us about ourselves.

But I mustn't preach. Everyone comes to Jane Austen in their own way. My daughter Anne recently had to read *Pride and Prejudice* for school. She is not a voracious reader like me, and I expected her to say 'boring'. I went carefully, trying not to put her off by my enthusiasm. And then she said, 'Oh, I hated ending that book.' There is a God.

The Battle

of the Sexes

Jane Austen is famous for having never written a scene that involved only men. Although she had many brothers, cousins, nephews, friends and beaux, it is sometimes assumed that she didn't know much about men, simply because she didn't marry. That was not true, as the following quotations demonstrate.

Austen knew well the slight tension that generally exists between members of the opposite sex, showing itself as playful mockery leading to flirtatiousness and love, or as real conflict leading to unhappiness and misunderstanding.

Men and women haven't changed much over the years. Women may have more independence and choice today, but I believe much of what Jane Austen had to say about the sexes is still true.

Austen's women weren't downtrodden. They had their say too, and one can see Austen as an early feminist, perhaps not trying to change the system, but surviving within it, dealing with men on equal terms and offering a social commentary on it.

Ultimately though, Jane Austen saw both men and women as – simply – people, with the same capacity to suffer and love.

Men love to distinguish themselves...

Mansfield Park

If there is any thing disagreeable going on, men are always sure to get out of it.

Persuasion

...one of that numerous class of females, whose society can raise no other emotion than surprise at there being any men in the world who could like them well enough to marry them.

Northanger Abbey

It would be mortifying to the feelings of many ladies, could they be made to understand how little the heart of man is affected by what is costly or new in their attire...

Northanger Abbey

Nothing in the way of pleasure can ever be given up by the young men of this age.

Sense and Sensibility

...that independence of spirit, which prevails so much in modern days, even in young women, and which in young women is offensive and disgusting beyond all common offence.

Mansfield Park

A young *woman* if she falls into bad hands, may be teazed, and kept at a distance from those she wants to be with; but one cannot comprehend a young *man's* being under such restraint.

Emma

You women are always thinking of men's being in liquor.

Northanger Abbey

Nursing does not belong to a man, it is not his province.

Persuasion

...when you men have a point to carry, you never stick at anything.

Northanger Abbey

...he was not yet so much in love as to measure distance, or reckon time with feminine lawlessness.

Mansfield Park

You men have such restless curiosity! Talk of the curiosity of women, indeed! – 'tis nothing.

Northanger Abbey

Leave him to chuse his own wife. Depend upon it, a man of six or seven-and-twenty can take care of himself.

Emma

A young man... so easily falls in love with a pretty girl for a few weeks, and when accident separates them, so easily forgets her.

Pride and Prejudice

...man has the advantage of choice, woman only the power of refusal...

Northanger Abbey

...it is always incomprehensible to a man that a woman should ever refuse an offer of marriage. A man always imagines a woman to be ready for anybody who asks her.

Emma

Let him have all the perfections in the world, I think it ought not to be set down as certain, that a man must be acceptable to every woman he may happens to like himself.

Mansfield Park

Perhaps no man can be a good judge of the comfort a woman feels in the society of one of her own sex.

Emma

You men have none of you any heart.

Northanger Abbey

I will not allow it to be more man's nature than woman's to be inconstant and forget those they do love, or have loved.

Persuasion

Town and

Country

In the world of Jane Austen's novels the countryside is depicted as being preferable to the city. Who would want a noisy, dirty town when one could have Austen's peaceful scenes of trees and hills and villages?

The reality was, of course, often different – the countryside wasn't always pretty and towns could be exciting, vibrant places. Yet the pastoral dream lives on.

However, this romantic picture probably did reflect Austen's own attitude to a large extent. Although she made many visits to London, and enjoyed what the city had to offer, she was at heart a countrywoman. It is well known, for instance, that she was devastated at the thought of leaving Steventon, her childhood home, for Bath, and was delighted when the family eventually left Bath.

The comments about London are particularly amusing. They could have been written this week, not 200 years ago. They could also have been written only by someone with knowledge of both ways of life. Jane Austen may have chosen to write about quiet village life, but she knew the wider world.

The final declaration belongs to Elizabeth Bennet in *Pride and Prejudice*, and sparkles with her wit and independence of spirit – and that of Jane Austen herself.

'When I am in the country,' he replied, 'I never wish to leave it; and when I am in town it is pretty much the same. They have each their advantages, and I can be equally happy in either.'

Pride and Prejudice

One day in the country is exactly like another.

Northanger Abbey

We do not look in great cities for our best morality.

Mansfield Park

London, where the reputation of elegance was more important and less easily obtained.

Sense and Sensibility

...the true London maxim, that every thing is to be got with money...

Mansfield Park

...the influence of London very much at war with all respectable attachments.

Mansfield Park

They came from Birmingham, which is not a place to promise much, you know, Mr Weston. One has not great hopes from Birmingham.

Emma

I was therefore entered at Oxford and have been properly idle ever since.

Sense and Sensibility

...I have heard that there is a great deal of wine drank in Oxford.

Northanger Abbey

...when we do return, it shall not be like other travellers, without being able to give one accurate idea of any thing. We *will* know where we have gone – we *will* recollect what we have seen. Lakes, mountains, and rivers, shall not be jumbled together in our imaginations; nor, when we attempt to describe any particular scene, will we begin quarrelling about its relative situation.

Pride and Prejudice

...as all must linger and gaze on a first return to the sea...

Persuasion

I am quite convinced, that, with very few exceptions, the sea-air always does good.

Persuasion

She sighed for the air, the liberty, the quiet of the country...

Sense and Sensibility

...feeling all the happy privilege of country liberty, of wandering from place to place in free and luxurious solitude...

Sense and Sensibility

...to sit in the shade on a fine day, and look upon verdure, is the most perfect refreshment.

Mansfield Park

What are men to rocks and mountains?

Pride and Prejudice

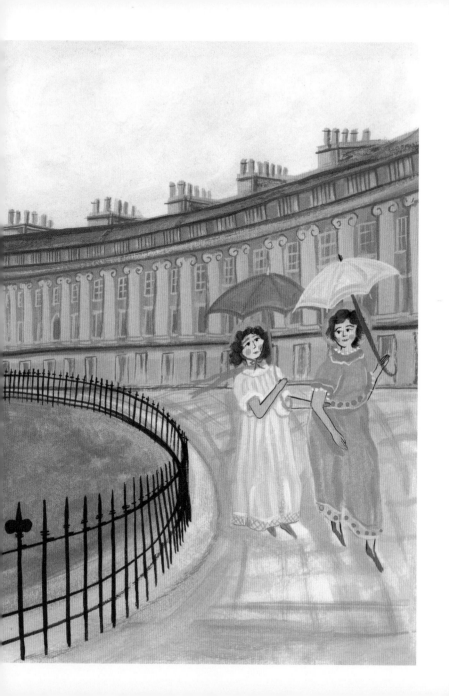

The Gaining

of Wisdom

She may have been seen as a 'husband-hunting butterfly' when she was young, but Jane Austen became a wise, sensible woman as she matured. Her nieces and nephews constantly asked her for advice, and always received thoughtful, kind counsel. Her great cleverness, combined with a warm and loving nature, made her a valuable confidante for many people.

In these excerpts from her work we, too, can profit from her advice. Her philosophy of life is probably best summarized as, 'Don't worry about things that may never happen,' and how we would all benefit from following that!

Underneath the surface detail of Austen's novels is a sense of sage and able mind, directing not only the events of the narrative, but also the mind of the reader; inviting us, in the most pleasurable way possible, to think more deeply, and learn as we read.

An occasional memento of past folly, however painful, might not be without use.

Northanger Abbey

...why did we wait for any thing? – why not seize the pleasure at once? – How often is happiness destroyed by preparation, foolish preparation!

Emma

...I am very sorry to be right in this instance. I would much rather have been merry than wise.

Emma

...one half of her should not be always so much wiser than the other half, or always suspecting the other of being worse than it was.

Persuasion

She had been forced into prudence in her youth, she learned romance as she grew older – the natural sequel of an unnatural beginning.

Persuasion

...agreeable as he was, she did not mean to be unhappy about him.

Pride and Prejudice

...to fret over unavoidable evils, or augment them by anxiety, was no part of her disposition.

Pride and Prejudice

It was not in her nature, however, to increase her vexations, by dwelling on them.

Pride and Prejudice

...he had learnt to distinguish between the steadiness of principle and the obstinacy of self-will, between the darings of heedlessness and the resolution of a collected mind.

Persuasion

...nor could she help fearing, on more serious reflection, that, like many other great moralists and preachers, she had been eloquent on a point in which her own conduct would ill bear examination.

Persuasion

She hoped to be wise and reasonable in time; but alas! alas! she must confess to herself that she was not wise yet.

Persuasion

Till this moment, I never knew myself.

Pride and Prejudice

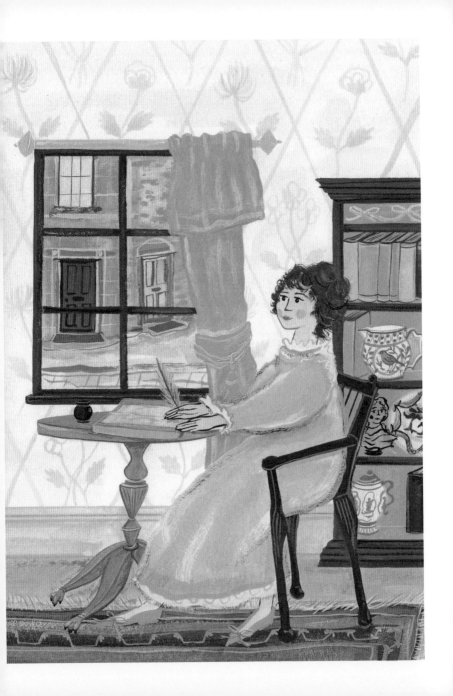

To be

Young Again

Teenagers as an identifiable social group are supposed to be a twentieth-century invention. They are supposed to be more difficult to deal with, be more of a problem, and have more problems themselves, than people of their age-group did in the past – yet Jane Austen's words on the subject could have been written today.

Here is comfort for parents struggling with their awkward teenagers! The fifteen year olds of long ago were a problem too, and yet they grew up to be sober citizens. Every age thinks its particular generation gap is the worst ever, but Jane Austen's comments prove that it isn't.

Growing up has always involved change. There have always been temptations to resist, decisions to be made, a path in life to be found. Fluctuating hormones, rebellion against one's parents – Jane Austen knew it all, and knew as well the excitement and discovery of changing from a child to an adult.

As always, Austen could laugh at the human condition while still sympathizing with it.

Aye, it is a fine thing to be young and handsome.

Sense and Sensibility

...a girl of fifteen! The very age of all others to need most attention and care, and put the cheerfullest spirits to the test.

Mansfield Park

...what young lady... will reach the age of sixteen without altering her name as far as she can.

Northanger Abbey

...her mind about as ignorant and uninformed as the female mind at seventeen usually is.

Northanger Abbey

To be Young Again

One does not like to see a girl of eighteen or nineteen so immediately up to every thing.

Mansfield Park

At nineteen, you know, one does not think very seriously.

Persuasion

...there is something so amiable in the prejudices of a young mind, that one is sorry to see them give way to the reception of more general opinions.

Sense and Sensibility

...if adventures will not befall a young lady in her own village, she must seek them abroad.

Northanger Abbey

...with all the liberal dispositions of an eldest son, who feels born only for expense and enjoyment.

Mansfield Park

I have often observed how little young ladies are interested by books of a serious stamp, though written solely for their benefit.

Pride and Prejudice

To look almost pretty, is an acquisition of higher delight to a girl who has been looking plain the first fifteen years of her life, than a beauty from her cradle can ever receive.

Northanger Abbey

To youth and natural cheerfulness like Emma's, though under temporary gloom at night, the return of day will hardly fail to bring return of spirits. The youth and cheerfulness of morning are in happy analogy, and of powerful operation; and if the distress be not poignant enough to keep the eyes unclosed, they will be sure to open to sensations of softened pain and brighter hope.

Emma

Human nature is so well disposed towards those who are in interesting situations, that a young person who either marries or dies, is sure of being kindly spoken of.

Emma

It is always good for young people to be put upon exerting themselves.

Northanger Abbey

Mothers certainly have not yet got quite the right way of managing their daughters.

Mansfield Park

Sorrow

and Joy

Jane Austen describes human feeling with the certainty of one who had experienced a wide range of emotions herself. Like all great writers she was at once a detached observer, noting the responses of those around her, and an active participant of life. This synthesis is one of the reasons for the richness of her work.

All the elements of her novels – plot, theme, character, tone, and so on – combine to make a brilliant whole. They are, however, driven by a deeper force than mere intellect – they come from the heart.

Austen could depict sparkling happiness, deep sadness or weary despair so accurately and completely that we don't just sympathize with her characters, we respond in kind, with laughter and tears. The level of our response grows with maturity, as we encounter more of life's complications, and learn that the state of permanent happiness youth desires is not only impossible, but somehow less important.

As Austen reminds us, every experience is valuable in itself.

I wish as well as every body else to be perfectly happy; but like every body else it must be in my own way.

Sense and Sensibility

...that sanguine expectation of happiness which is happiness itself.

Sense and Sensibility

...was exactly in that state of recently-improved views, of fresh-formed happiness, which made her full of regard and interest for every body she had ever liked before at all...

Persuasion

She was in good humour with all. She had received ideas which disposed her to be courteous and kind to all, and to pity every one, as being less happy than herself.

Persuasion

...her happiness was of a quiet, deep, heart-swelling sort...

Mansfield Park

I am the happiest creature in the world.

Pride and Prejudice

She was, she felt she was in the greatest danger of being exquisitely happy, while so many were miserable.

Mansfield Park

...smiles reined in and spirits dancing in private rapture.

Persuasion

What have wealth or grandeur to do with happiness?

Sense and Sensibility

...money can only give happiness where there is nothing else to give it.

Sense and Sensibility

...we all know at times what it is to be wearied in spirits. Mine, I confess, are exhausted.

Emma

...all the anxiety of expectation and the pain of disappointment.

Sense and Sensibility

Once so much to each other! Now nothing!

Persuasion

Now they were as strangers; nay, worse than strangers, for they could never become acquainted. It was a perpetual estrangement.

Persuasion

Her sigh had none of the ill-will of envy in it. She would certainly have risen to their blessings if she could, but she did not want to lessen theirs.

Persuasion

...misery such as mine has no pride. I care not who knows that I am wretched.

Sense and Sensibility

There is nothing like employment, active, indispensable employment, for relieving sorrow.

Mansfield Park

Oh! how easy for those who have no sorrow of their own to talk of exertion.

Sense and Sensibility

Perfect happiness, even in memory, is not common...

Emma

Think only of the past as its remembrance gives you pleasure.

Pride and Prejudice

...when pain is over, the remembrance of it often becomes a pleasure. One does not love a place the less for having suffered in it, unless it has been all suffering...

Persuasion

Character and

Characters

Here is Jane Austen at her most wicked, contemplating other people from her amused, discerning viewpoint. How delicious are her observations! How sure are her descriptions! How many of our friends and relations do we not recognize here! Austen had a very large acquaintance, and she liked to sit back and observe people, so it is not surprising that as well as commenting on her novels' individual characters and their particular foibles, she should also comment on human nature in general.

Her own friends and relations may have looked for themselves in her books, but she said she preferred to create her own characters, and she was not a particularly biographical writer. Nevertheless, her knowledge of human nature was drawn from life, so it's amusing to speculate on whose idiosyncrasies provided inspiration for her famous comic characters, such as Mr Collins in *Pride and Prejudice* or Miss Bates in *Emma*.

Some of her portraits are so unflattering that one could almost assume she had a dislike of people in general, until one reads more carefully and sees that the people and traits most savagely portrayed probably deserved the treatment they received. Selfishness and vanity attracted most censure. Kindness and sense were valued.

She had the courage to portray people as they really were: at their worst, but still providing us with much amusement; and at their best, reassuring us that there are many good and sensible people in this world.

I am convinced that there is a vast deal of inconsistency in almost
every human character.

Sense and Sensibility

There are few people whom I really love, and still fewer of whom I
think well. The more I see of the world, the more am I dissatisfied
with it; and every day confirms my belief of the inconsistency of all
human characters, and of the little dependence that can be placed
on the appearance of either merit or sense.

Pride and Prejudice

Here and there, human nature may be great in times of trial, but
generally speaking it is its weakness and not its strength that
appears in a sick chamber; it is selfishness and impatience rather
than generosity and fortitude, that one hears of.

Persuasion

There are people, who the more you do for them, the less they will
do for themselves.

Emma

Selfishness must always be forgiven you know, because there is no hope of a cure.

Mansfield Park

Oh! I always deserve the best treatment, because I never put up with any other.

Emma

Those who do not complain are never pitied.

Pride and Prejudice

Nothing ever fatigues me, but doing what I do not like.

Mansfield Park

...what an earnest, an unceasing self-interest, however its progress may be apparently obstructed, will do in securing every advantage of fortune, with no other sacrifice than that of time and conscience.

Sense and Sensibility

Their vanity was in such good order, that they seemed to be quite free from it, and gave themselves no airs...

Mansfield Park

One cannot wonder that so very a fine young man, with family, fortune, every thing in his favour, should think highly of himself.

Pride and Prejudice

It is a great deal more natural than one could wish, that a young man, brought up by those who are proud, luxurious, and selfish, should be proud, luxurious, and selfish too.

Emma

The world had made him extravagant and vain – Extravagance and vanity had made him cold-hearted and selfish.

Sense and Sensibility

Vanity working on a weak head, produces every sort of mischief.

Emma

There is, I believe, in every disposition a tendency to some particular evil, a natural defect, which not even the best education can overcome.

Pride and Prejudice

...she had prejudices on the side of ancestry; she had a value for rank and consequence, which blinded her a little to the faults of those who possessed them.

Persuasion

...to flatter and follow others, without being flattered and followed in turn, is but a state of half enjoyment.

Persuasion

...why he should say one thing so positively, and mean another all the while, was most unaccountable! How were people, at that rate to be understood?

Northanger Abbey

Modesty, and all that, is very well in its way, but really a little common honesty is sometimes quite as becoming.

Northanger Abbey

The indignities of stupidity, and the disappointments of selfish passion, can excite little pity.

Mansfield Park

'He likes to have his own way very well,' ... 'but so we all do. It is only that he has better means of having it than many others, because he is rich, and many others are poor.'

Pride and Prejudice

...one of those well-meaning people, who are always doing mistaken and very disagreeable things.

Mansfield Park

...angry people are not always wise...

Pride and Prejudice

I never wish to offend, but I am so foolishly shy, that I often seem negligent, when I am only kept back by my natural awkwardness.

Sense and Sensibility

Shyness is only the effect of a sense of inferiority in some way or other.

Sense and Sensibility

She expected from other people the same opinions and feelings as her own, and she judged of their motives by the immediate effect of their actions on herself.

Sense and Sensibility

What wild imaginations one forms, where dear self is concerned! How sure to be mistaken.

Persuasion

To be always firm must be to be often obstinate.

Northanger Abbey

I have no idea of being so easily persuaded. When I have made up my mind, I have made it.

Persuasion

Opposition on so tender a subject would only attach her the more to her own opinion.

Sense and Sensibility

[he] is a man... whom every body speaks well of, and nobody cares about; whom all are delighted to see, and nobody remembers to talk to.

Sense and Sensibility

A man who has nothing to do with his own time has no conscience in his intrusions on that of others.

Sense and Sensibility

...there are very few of us who do not cherish a feeling of self-complacency on the score of some quality or other, real or imaginary.

Pride and Prejudice

...with them, to wish was to hope, and to hope was to expect.

Sense and Sensibility

Her manners were open, easy, and decided, like one who had no distrust of herself, and no doubts of what to do...

Persuasion

Every thing united in him; good understanding, correct opinions, knowledge of the world, and a warm heart.

Persuasion

Such a man could come from no place, no society, without importing something to amuse...

Mansfield Park

There is a quickness of perception in some, a nicety in the discernment of character, a natural penetration, in short, which no experience in others can equal.

Persuasion

Good sense, like hers, will always act when really called upon...

Mansfield Park

She felt that she could so much more depend upon the sincerity of those who sometimes looked or said a careless or hasty thing, than of those whose presence of mind never varied, whose tongue never slipped.

Persuasion

...a sanguine temper, though for ever expecting more good than occurs, does not always pay for its hopes by any proportionate depression. It soon flies over the present failure, and begins to hope again.

Emma

I am not born to sit still and do nothing. If I lose the game, it shall not be from not striving for it.

Mansfield Park

'My idea of good company... is the company of clever, well-informed people, who have a great deal of conversation; that is what I call good company.' 'You are mistaken,' said he gently, 'that is not good company, that is the best.'

Persuasion

There is

a Season

The British are supposed to spend a lot of time talking about the weather, and, indeed, it is a very useful, innocuous topic of conversation in many circumstances. But there is more to it than that. The weather on any particular day, as well as the season of the year and the time of day, all have an effect on our emotions.

Jane Austen, living in and writing about the country, was closer to the seasons than modern town-dwellers, yet nothing she wrote on this topic is outside our experience. Even today, with all our clever devices to protect us from the elements, there seems something in us that responds to the drama of a storm or extremes of temperature. Perhaps we are excited and a little afraid of proof that we cannot control our world as much as we would like to.

The slow rotation of the seasons also provides much pleasure. Most of us have a favourite time of year, but can still enjoy the kaleidoscope of the unfolding calendar. Indeed, its very impermanence makes each season precious.

More than anything else, it is the changes throughout the year that bring us closest to understanding time – or perhaps to realizing that we never can understand it.

How wonderful, how very wonderful the operations of time, and the changes of the human mind.

Mansfield Park

...there is a time for every thing – a time for balls and plays, and a time for work.

Northanger Abbey

...time will do almost every thing...

Mansfield Park

...to retentive feelings eight years may be little more than nothing...

Persuasion

...a wet Sunday evening – the very time of all others if when a friend is at hand the heart must be opened, and every thing told...

Mansfield Park

...the spirits of evening giving fresh courage...

Mansfield Park

...from first seeing the place under the advantage of good weather, they received an impression in its favour.

Sense and Sensibility

Our weather must not always be judged by the calendar. We may sometimes take greater liberties in November than in May.

Mansfield Park

Dullness is as much produced within doors as without, by rain. It makes one detest all one's acquaintance.

Sense and Sensibility

Some people were always cross when they were hot.

Emma

...the trees, though not fully clothed, were in that delightful state, when farther beauty is known to be at hand, and when, while much is actually given to the sight, more yet remains for the imagination.

Mansfield Park

...autumn, that season of peculiar and inexhaustible influence on the mind of taste and tenderness, that season which has drawn from every poet, worthy of being read, some attempt at description, or some lines of feeling.

Persuasion

...all the influence so sweet and so sad of the Autumnal months in the country...

Persuasion

...the last smiles of the year upon the tawny leaves and withered hedges...

Persuasion

There is a Season

Our

Moral Duty

On one level Jane Austen appears to be a frivolous writer, making fun of everybody and everything, taking nothing seriously – yet of course this is not the case.

Certainly she ridiculed much that was silly and conceited. Perhaps, like many clever people, she was rather intolerant of those who couldn't help their own stupidity, but counterbalancing her immense intellect was her strong sense of right and wrong. She wasn't an arrogant intellectual snob, but an intelligent, moral woman, whose ultimate message was that of doing the right thing by others.

Cleverness and morality don't always go together, and certainly aren't often combined with comic genius, yet it was so with Jane Austen. It is possibly this unique combination of traits that have ensured the endurance of her novels.

We needn't feel guilty about laughing at Austen's biting wit, because we are being nourished by solid fare at the same time.

Respect for right conduct is felt by everybody.

Emma

We have all a better guide in ourselves if we would attend to it, than any other person can be.

Mansfield Park

...the most valuable knowledge we could any of us acquire – the knowledge of ourselves and of our duty...

Mansfield Park

There is one thing, Emma, which a man can always do, if he chuses, and that is, his duty; not by manoeuvring and finessing, but by vigour and resolution.

Emma

There is always something offensive in the details of cunning. The manoeuvres of selfishness and duplicity must ever be revolting.

Persuasion

...disguise of every sort is my abhorrence.

Pride and Prejudice

...the temptation of immediate pleasure was too strong for a mind unused to make any sacrifice to right...

Mansfield Park

...we were a thoughtless, gay set, without any strict rules of conduct. We lived for enjoyment.

Persuasion

...the advantage of early hardship and discipline, and the consciousness of being born to struggle and endure.

Mansfield Park

I would not attempt to force the confidence of any one; of a child much less; because a sense of duty would prevent the denial which her wishes might direct.

Sense and Sensibility

The old, well-established grievance of duty against will, parent against child.

Sense and Sensibility

I am not one of those who neglect the reigning power to bow to the rising sun.

Persuasion

It was, perhaps, one of those cases in which advice is good or bad only as the event decides.

Persuasion

...silly things do cease to be silly if they are done by sensible people in an impudent way. Wickedness is always wickedness, but folly is not always folly – It depends upon the character of those who handle it.

Emma

I hope I never ridicule what is wise or good. Follies and nonsense, whims and inconsistencies do divert me, I own...

Pride and Prejudice

...the person who had contracted debts must pay them...

Persuasion

...our pleasures in this world are always to be paid for...

Northanger Abbey

...we always know when we are acting wrong...

Sense and Sensibility

From

Attraction...

As the six famous Austen novels are all love stories, it is inevitable that there are many references to the interaction between men and women.

Jane Austen understood very well the courtship games that people play. She was popular and sought-after in her youth, she knew how to attract, she knew what attracted her. She wrote with authority on the subtle art of flirting, the art that conceals a terribly important purpose, especially for women in the early nineteenth century, that of attracting a partner and ensuring one's future.

How far should a woman go in trying to attract a man? What will he find most appealing – good looks, a pleasant personality, or a quick mind? Or can a manipulative woman pretend to be whatever she thinks her quarry wants her to be...? Some of her pleas for women to conceal their intelligence have a slightly acid touch. Was Jane Austen, for once, indulging in a little personal reflection? If so, there are clever women, even today, who will empathize with her.

The idea of the woman preening herself to attract a man is not new. In theory, women are elusive treasures which man must pursue and overcome, but in practice it is usually the man who is the prize – desired by more than one woman. Which one will he choose – or rather which one will win the undeclared war?

...if a woman is partial to a man, and does not endeavour to conceal it, he must find it out.

Pride and Prejudice

A lady's imagination is very rapid; it jumps from admiration to love, from love to matrimony in a moment.

Pride and Prejudice

It is very often nothing but our own vanity that deceives us. Women fancy admiration means more than it does.

Pride and Prejudice

An engaged woman is always more agreeable than a disengaged. She is satisfied with herself. Her cares are over, and she feels that she may exert all her powers of pleasing without suspicion. All is safe with a lady engaged; no harm can be done.

Mansfield Park

He was entangled by his own vanity, with as little excuse of love as possible...

Mansfield Park

That would be the greatest misfortune of all! – To find a man agreeable whom one is determined to hate!

Pride and Prejudice

...he was mortified, he could not bear to be thrown off by the woman whose smiles had been so wholly at his command...

Mansfield Park

She was a clever young woman, who understood the art of pleasing...

Persuasion

[She] is one of those young ladies who seek to recommend themselves to the other sex, by undervaluing their own, and with many men, I dare say, it succeeds.

Pride and Prejudice

...there is meanness in all the arts which ladies sometimes condescend to employ for captivation.

Pride and Prejudice

Now she has really got the man she likes, she may be constant.

Northanger Abbey

There is safety in reserve, but no attraction. One cannot love a reserved person.

– Not till the reserve ceases towards oneself; and then the attraction may be the greater.

Emma

...to be unaffected was all that a pretty girl could want to make her mind as captivating as her person.

Sense and Sensibility

Good-humoured, unaffected girls, will not do for a man who has been used to sensible women.

Mansfield Park

There is hardly any personal defect... which an agreeable manner might not gradually reconcile one to.

Persuasion

From Attraction...

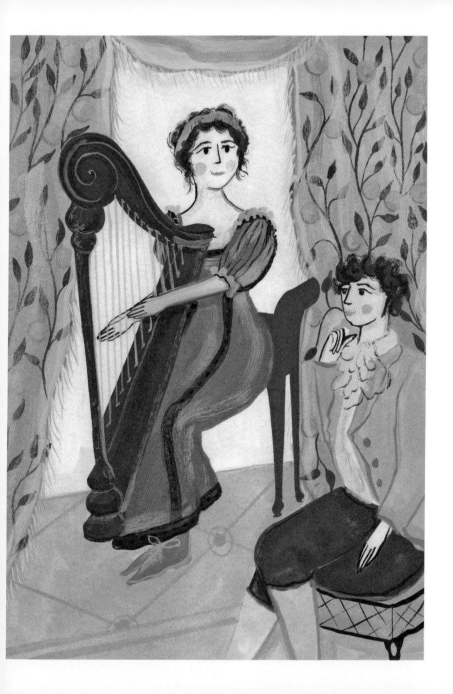

...an agreeable manner may set off handsome features, but can never alter plain ones.

Persuasion

I am very much mistaken if your sex in general would not think such beauty, and such temper, the highest claims a woman could possess.

Emma

Where people wish to attach, they should always be ignorant. To come with a well informed mind is to come with an inability of administering to the vanity of others, which a sensible person would always wish to avoid. A woman especially, if she have the misfortune of knowing anything, should conceal it as well as she can.

Northanger Abbey

...a good-looking girl, with an affectionate heart and a very ignorant mind, cannot fail of attracting a clever young man, unless circumstances are particularly untoward.

Northanger Abbey

It sometimes happens, that a woman is handsomer at twenty-nine than she was ten years before...

Persuasion

...she was to be blessed with a second spring of youth and beauty.

Persuasion

I have been meditating on the very great pleasure which a pair of fine eyes in the face of a pretty woman can bestow.

Pride and Prejudice

...he should learn to prefer soft light eyes to sparkling dark ones.

Mansfield Park

She prized the frank, the open-hearted, the eager character beyond all others. Warmth and enthusiasm did captivate her still.

Persuasion

There is no charm equal to tenderness of heart... Warmth and tenderness of heart, with an affectionate, open manner, will beat all the clearness of head in the world, for attraction.

Emma

...To

Love...

Love is the energy driving Jane Austen's novels. Cynics think they are about marriage and money, but that is not so. In all the books, from the light and frothy *Pride and Prejudice* to the sadder, slower *Persuasion*, love is the over-riding theme.

It is all there – the preoccupation of some people with the idea of being in love; the tremulous excitement of first falling in love; the sadness of unrequited love and the pain of jealousy; the deceptions people practise on themselves and others in the name of love; the immense happiness and satisfaction that comes with mature love.

Anyone who has been in love will identify with Jane Austen's words. They strike a deep chord, clarifying and validating our own feelings. It is special indeed to love, or be loved, and when the two go together...

No-one who reads this anthology could doubt that Austen herself knew what it was to love. Whether it was the unknown man at Sidmouth or some other of whom we know nothing doesn't matter. We don't need names or dates. Her understanding of love shines very clearly throughout her work.

...no one can ever be in love more than once in their life...

Sense and Sensibility

...the more I know of the world, the more I am convinced that I shall never see a man whom I can really love.

Sense and Sensibility

If I loved you less, I might be able to talk about it more.

Emma

...I did not then know what it was to love.

Sense and Sensibility

...these violent young lovers carry every thing their own way.

Pride and Prejudice

Harriet was one of those, who, having begun, would be always in love.

Emma

...To Love...

...being inclined to marry, soon fancied himself in love...

Mansfield Park

...he was of an age to be all for love...

Mansfield Park

...actually looking round, ready to fall in love with all the speed which a clear head and quick taste could allow.

Persuasion

...any tolerably pleasing young woman who had listened and seemed to feel for him, would have received the same compliment. He had an affectionate heart. He must love somebody.

Persuasion

You are too sensible a girl... to fall in love merely because you are warned against it.

Pride and Prejudice

...any thing interests between those who love; and any thing will serve as introduction to what is near the heart.

Emma

To be fond of dancing was a certain step towards falling in love.

Pride and Prejudice

It would be something to be loved by such a girl, to excite the giant ardours of her young, unsophisticated mind!

Mansfield Park

...you know no actual good of me – but nobody thinks of that when they fall in love.

Pride and Prejudice

...that sweetness which makes so essential a part of every woman's worth in the judgement of man, that though he sometimes loves where it is not, he can never believe it absent.

Mansfield Park

...there is nothing people are so often deceived in, as the state of their own affection...

Northanger Abbey

...it often happens, that a man, before he has quite made up his own mind, will distinguish the sister or intimate friend of the woman he is really thinking of, rather than the woman herself.

Mansfield Park

...jealousy had not yet made her desperate...

Pride and Prejudice

No man is offended by another man's admiration of the woman he loves; it is the woman only who can make it a torment.

Northanger Abbey

I wonder who first discovered the efficacy of poetry in driving away love!

Pride and Prejudice

...he will be a discreeter man all his life, for the foolishness of his first choice.

Northanger Abbey

If the girl likes another man better, it is very fit she should have him.

Persuasion

Friendship is certainly the finest balm for the pangs of disappointing love.

Northanger Abbey

...there could have been no two hearts so open, no tastes so similar, no feelings so in unison, no countenances so beloved.

Persuasion

...though a very few hours spent in the hard labour of incessant talking will dispatch more subjects than can really be in common between any two rational creatures, yet with lovers it is different. Between them no subject is finished, no communication is even made, till it has been made at least twenty times.

Sense and Sensibility

Where the heart is really attached, I know very well how little one can be pleased with the attentions of anybody else.

Northanger Abbey

Surely, if there be constant attachment on each side, our hearts must understand each other ere long.

Persuasion

...never had she so honestly felt that she could have loved him, as now, when all love must be vain.

Pride and Prejudice

If she could only have a few minutes conversation with him again, she fancied she should be satisfied...

Persuasion

...the cure of unconquerable passions, and the transfer of unchanging attachments, must vary much as to time in different people.

Mansfield Park

A man does not recover from such a devotion of the heart to such a woman! – He ought not – he does not.

Persuasion

...they exchanged again those feelings and those promises which had once before seemed to secure every thing, but which had been followed by so many, many years of division and estrangement.

Persuasion

Let no one presume to give the feelings of a young woman on receiving the assurance of that affection of which she has scarcely allowed herself to entertain a hope.

Mansfield Park

...all that was happy and gay, all that was glowing and bright in prosperous love.

Persuasion

... To

Marriage

Austen is best known for her irony, and surely it is the supreme irony that although her novels have marriage as their subject matter they would probably not exist if Jane Austen herself had ever married. Married women in the early nineteenth century were tied to household chores, to the nurturing of husband and children. She recognized this herself, saying, – 'Composition seems to me Impossible, with a head full of Joints of Mutton and doses of Rhubarb.' To which even many modern women, trying to balance creativity and achievement with domesticity, would say, 'Amen!'

Despite never marrying, she certainly had her chances – there were several proposals, some disappointments, possibly a bereavement. But she would not marry without love. Despite the preoccupation in the novels with the heroines marrying well, the author's true feelings were summed up by her advice to her niece Fanny that 'Anything is to be Preferred or endured rather than marrying without Affection'.

This belief comes through very strongly in all the novels. In any age when women couldn't easily earn a living for themselves, and eldest sons inherited everything, marriage was absolutely necessary for women's comfort, if not actual survival; yet all the novels stress the importance of marrying for love, it is the unifying theme. Jane Austen was herself dependent on her brothers' goodwill – she must have seen parallels between her own situation and that of poor Miss Bates in *Emma*, yet she would not compromise.

Charlotte Lucas's cool, practical attitude in *Pride and Prejudice* was really more sensible than that of Jane Austen's more romantic characters, yet our modern notion of marriage – that it should be based on both passion and companionship – means that we empathize with Emma and Elizabeth Bennet and Anne Elliot, and we love the happy endings.

Happiness in marriage is entirely a matter of chance. If the dispositions of the parties are ever so well known to each other, or ever so similar before-hand, it does not advance their felicity in the least.

Pride and Prejudice

She would hesitate, she would tease, she would condition, she would require a great deal but she would finally accept.

Mansfield Park

...the expectations of one wedding, made every body eager for another...

Pride and Prejudice

...there is not one in a hundred of either sex, who is not taken in when they marry... it is, of all transactions, the one in which people expect most from others, and are least honest themselves.

Mansfield Park

I know so many who have married in the full expectation and confidence of some one particular advantage in the connection, or accomplishment or good quality in the person, who have found themselves entirely deceived, and been obliged to put up with exactly the reverse!

Mansfield Park

...do any thing rather than marry without affection.

Pride and Prejudice

...to marry for money I think the wickedest thing in existence.

Northanger Abbey

...it is not every man's fate to marry the woman who loves him best.

Emma

I should hope it would be a very happy match. There are on both sides good principles and good temper.

Persuasion

I would rather have young people settle on a small income at once, and have to struggle with a few difficulties together, than be involved in a long engagement.

Persuasion

When any two young people take it into their heads to marry, they are pretty sure by perseverance to carry their point, be they ever so poor, or ever so imprudent, or ever so little likely to be necessary to each other's ultimate comfort.

Persuasion

It would be an excellent match, for he was rich and she was handsome.

Sense and Sensibility

...what is the difference in matrimonial affairs, between the mercenary and the prudent motive? Where does discretion end, and avarice begin?

Pride and Prejudice

When one lives in the world, a man or woman's marrying for money is too common to strike one as it ought.

Persuasion

If there is a good fortune on one side, there can be no occasion for any on the other. No matter which has it, so that there is enough.

Northanger Abbey

There certainly are not so many men of large fortune in the world, as there are pretty women to deserve them.

Mansfield Park

In marriage, the man is supposed to provide for the support of the woman; the woman to make the home agreeable to the man...

Northanger Abbey

I am not romantic you know. I never was. I ask only a comfortable home.

Pride and Prejudice

A man would always wish to give a woman a better home than the one he takes her from.

Emma

Was it a new circumstance for a man of first-rate abilities to be captivated by very inferior powers? Was it new for one, perhaps too busy to seek, to be the prize of a girl who would seek him?

Emma

To his wife he was very little otherwise indebted, than as her ignorance and folly had contributed to his amusement.

Pride and Prejudice

His temper might perhaps be a little soured by finding, like many others of his sex, that through some unaccountable bias in favour of beauty, he was the husband of a very silly woman.

Sense and Sensibility

...the strange unsuitableness which often existed between husband and wife.

Sense and Sensibility

...[he] will not be the first man who has chosen a wife with less sense than his family expected.

Northanger Abbey

...a more equal match might have greatly improved him; and that a woman of real understanding might have given more consequence to his character...

Persuasion

You have made your own choice. It was not forced on you. Your wife has a claim to your politeness, to your respect, at least.

Sense and Sensibility

She hoped to marry him, and they continued together till she was obliged to be convinced that such hope was in vain and till the disappointment and wretchedness arising from the conviction, rendered her temper so bad, and her feelings for him so like hatred, as to make them for a while each other's punishment, and then induce a voluntary separation.

Mansfield Park

Nothing so easy as for a young lady to raise her expectations too high. Men of sense, whatever you may choose to say, do not want silly wives.

Emma

...if you take it into your head to go on refusing every offer of marriage in this way, you will never get a husband at all.

Pride and Prejudice

A woman is not to marry a man merely because she is asked, or because he is attached to her...

Emma

Without thinking highly either of men or of matrimony, marriage had always been her object...

Pride and Prejudice

I know that you could be neither happy nor respectable, unless you truly esteemed your husband; unless you looked up to him as a superior.

Pride and Prejudice

He is blinded, and nothing will open his eyes, nothing can, after having had truths before him so long in vain – he will marry her, and be poor and miserable.

Mansfield Park

Well, I have so little confidence in my own judgement, that whenever I marry, I hope somebody will choose my wife for me.

Emma

It is only by seeing women in their own homes, among their own set, just as they always are, that you can form any just judgment. Short of that, it is all guess and luck – and will generally be ill-luck. How many a man has committed himself on a short acquaintance, and rued it all the rest of his life.

Emma

...can I be happy... in accepting a man whose sisters and friends are all wishing him to marry elsewhere?

Pride and Prejudice

You could not have made me the offer of your hand in any possible way that would have tempted me to accept it.

Pride and Prejudice

...I had not known you a month before I felt that you were the last man in the world whom I could ever be prevailed on to marry.

Pride and Prejudice

The extreme sweetness of her temper must hurt his.

Emma

His second [marriage] must show him how delightful a well-judging and truly amiable woman could be, and must give him the pleasantest proof of its being a great deal better to chuse than to be chosen, to excite gratitude than to feel it.

Emma

...his fault, the liking to make girls a little in love with him, is not half so dangerous as a wife's happiness, as a tendency to fall in love himself...

Mansfield Park

Husbands and wives generally understand when opposition will be in vain.

Persuasion

...he said it very prettily. What he might say on the subject a twelvemonth after, must be referred to the imagination of husbands and wives.

Sense and Sensibility

To begin perfect happiness at the respective ages of twenty-six and eighteen, is to do pretty well.

Northanger Abbey

The marriage of – and – had had its day of fame and pleasure, hope and interest.

Emma

Hope and

Family

Unlike many of her contemporary female novelists, Jane Austen wrote about everyday life rather than unlikely adventures in far-off places, and her books are full of fascinating particulars about the homes and families of her time. Many of the details of domestic life have changed – but not the essentials. For instance, it is amusing and revealing to read that people in the early nineteenth century felt impatience at the time it took tradesmen to complete a task. Who can not identify with that sentiment?

The author's own family was exceptionally close, loving and supportive, and this is apparent in all the novels. The value of family ties is constantly stressed, not as a sermon, but as part of the overall fabric of the books, an underlying assumption that unobtrusively colours everything else. We are left with a feeling of warmth and respect for the family as a social unit.

Jane Austen's comments on children and indulgent parents are amusing, even though they don't reflect her relations with her own numerous nieces and nephews, who generally regarded her with great affection and respect, and to a few of whom she was almost a surrogate mother.

Yet for all the happiness Jane Austen found in her family circle, she knew the complexities and difficulties inherent in that institution. She knew about family secrets...

Let me only have the girl I like, say I, with a comfortable house over my head, and what care I for all the rest.

Northanger Abbey

...the joyfulness of family love...

Northanger Abbey

...the unpretending comfort of a well connected Parsonage.

Northanger Abbey

...it is a long while since I have been at home, and you know one has always a world of little odd things to do after one has been away for any time...

Sense and Sensibility

...after experiencing, as usual, a thousand disappointments and delays, from the unaccountable dilatoriness of the workmen.

Sense and Sensibility

A well-disposed young woman, who did not marry for love, was in general but the more attached to her own family.

Mansfield Park

...even the conjugal tie is beneath the fraternal. Children of the same family, the same blood, with the same first associations and habits, have some means of enjoyment in their power, which no subsequent connections can supply...

Mansfield Park

...an absolute breach between the sisters had taken place. It was the natural result of the conduct of each party, and such as a very imprudent marriage always produces.

Mansfield Park

With such a reward for her tears, the child was too wise to cease crying.

Sense and Sensibility

...a fond mother, though, in pursuit of praise for her children the most rapacious of human beings, is likewise the most credulous.

Sense and Sensibility

I love to see children full of life and spirits; I cannot bear them if they are tame and quiet.

Sense and Sensibility

...all the indulgent fondness of a parent towards a favourite child on the last day of its holidays.

Sense and Sensibility

...in consequence of being the only plain one in the family, worked hard for knowledge and accomplishments...

Pride and Prejudice

I make a rule of never interfering, in any of my daughter-in-law's concerns, for I know it would not do...

Persuasion

Even the smooth surface of family-union seems worth preserving, though there may be nothing durable beneath.

Persuasion

...her own sister must be better than her husband's sisters.

Persuasion

It was consoling, that he should know she had some relations for whom there was no need to blush.

Pride and Prejudice

Wherever you are you should always be contented, but especially at home, because there you must spend the most of your time.

Northanger Abbey

It is very unfair to judge of any body's conduct, without an intimate knowledge of their situation. Nobody, who has not been in the interior of a family, can say what the difficulties of an individual of that family may be.

Emma

Family connexions were always worth preserving...

Persuasion

There are secrets in all families, you know...

Emma

In Public

and Private

Jane Austen led a very busy social life – particularly when she was young – balls and private parties being the most popular occasions.

In the days before the internet made communication easier, big social events were very important, not just in themselves, but as an occasion for people to come together and talk. People might not meet at all in the intervals between dinners and balls, nor could they chat on the telephone to keep in touch – hence the many references to the exchange of gossip under cover of loud music and talk. Also, girls of Jane Austen's class did not work, nor participate in civic life to any extent. One's party manners were therefore crucial in determining one's character and standing in the community.

Despite these differences from our own time, what Jane Austen had to say on the conventions of social life remains relevant for us. We still have to put on our public face, to hide what we are really thinking. Society indeed has claims on us all, in a broader sense than that referred to by Mary Bennet in *Pride and Prejudice*.

Society has claims on us all.

Pride and Prejudice

The world is blinded by his fortune and consequence, or frightened by his high and imposing manners, and sees him only as he chuses to be seen.

Pride and Prejudice

Vanity and pride are different things, though the words are often used synonymously. A person may be proud without being vain. Pride relates more to our opinion of ourselves, vanity to what we would have others think of us.

Pride and Prejudice

...people are never respected when they step out of their own proper sphere.

Mansfield Park

...the active, contriving manager, uniting at once a desire of smart appearance, with the utmost frugality, and ashamed to be suspected of half her economical practices...

Sense and Sensibility

I am particularly unlucky in meeting with a person so well able to expose my real character, in a part of the world, where I had hoped to pass myself off with some degree of credit.

Pride and Prejudice

Emma denied none of it aloud, and agreed to none of it in private.

Emma

...she had the comfort of appearing very polite, while feeling very cross...

Emma

...they parted at last with mutual civility, and possibly a mutual desire of never meeting again.

Pride and Prejudice

...I may observe that private balls are much pleasanter than public ones.

Pride and Prejudice

...five is the very awkwardest of all possible numbers to sit down to table...

Mansfield Park

...it will be a small party, but where small parties are select, they are perhaps the most agreeable of any.

Emma

'This is the luxury of a large party,' said she: – 'one can get near everybody, and say everything...'

Emma

There had been music, singing, talking, laughing, all that was most agreeable...

Persuasion

Give me but a little cheerful company, let me only have the company of the people I love, let me only be where I like and with whom I like, and the devil may take the rest, say I.

Northanger Abbey

Language

and Letters

As one would expect, a great novelist like Jane Austen had much to say about our language and its intricacies, strengths and limitations. She had even more to say about the uses to which people put it. The snap and sparkle of her irony spared nobody – the pompous snob, the tiresome, garrulous windbag, the tongue-tied mute. We know them all. And how interesting to note, too, that jargon and hackneyed speech are not new. Austen worked hard to keep her own writing free of both, unlike many other novelists of her time.

There are many references to letters in the novels, which is not surprising given that they were the main form of communication then. Yet letters are not so unusual today that we cannot identify with many of Austen's observations. Who has not struggled to write a difficult letter, feeling the pen drag with every word, wondering if the reader will recognize the effort of composition? Who has not enjoyed a well-written, lively letter, and wanted more?

...the commonest, dullest, most threadbare topic might be rendered interesting by the skill of the speaker.

Pride and Prejudice

'I certainly have not the talent which some people possess,' [he] said, 'of conversing easily with those I have never seen before. I cannot catch their tone of conversation, or appear interested in their concerns, as I often see done.'

Pride and Prejudice

...this is too much, to remember at night all the foolish things that were said in the morning.

Pride and Prejudice

...sometimes I have kept my feelings to myself, because I could find no language to describe them in but what was worn and hackneyed out of all sense and meaning.

Sense and Sensibility

I detest jargon of every kind.

Sense and Sensibility

Language and Letters

I cannot speak well enough to be unintelligible.

Northanger Abbey

...though not saying much to the purpose, could talk of nothing else.

Mansfield Park

...though never a great talker, she was always more inclined to silence when feeling most strongly.

Mansfield Park

She was not a woman of many words: for unlike people in general, she proportioned them to the number of her ideas...

Sense and Sensibility

She had nothing to say one day that she had not said the day before.

Sense and Sensibility

...in that inconvenient tone of voice which was perfectly audible while it pretended to be a whisper...

Persuasion

Never is a black word. But yes, in the never of conversation which means not very often...

Mansfield Park

...Shakespeare one gets acquainted with without knowing how. It is a part of an Englishman's constitution.

Mansfield Park

...we all talk Shakespeare, use his similes, and describe with his descriptions...

Mansfield Park

Letters are no matter of indifference; they are generally a very positive curse.

Emma

...her letters were always long expected, and always very short.

Pride and Prejudice

...all the toil of keeping up a slow and unsatisfactory correspondence.

Persuasion

Every body allows that the talent of writing agreeable letters is particularly female.

Northanger Abbey

Oh! the blessing of a female correspondent, when one is really interested in the absent! – she will tell me every thing.

Emma

...no private correspondence could bear the eye of others.

Persuasion

Facts or opinions which are to pass through the hands of so many, to be misconceived by folly in one, and ignorance in another, can hardly have much truth left.

Persuasion

The Human

Experience

Here we come to the heart of Jane Austen's work and here we see her deep knowledge of people revealed. We read truths that are as relevant today as they were in the early eighteen hundreds or the Dark Ages – or, no doubt, in Prehistoric times.

The journey through life may differ in detail from one person to another, but there is something universal in all that we do, say and think. Our responses, our thought processes, our patterns of behaviour, are very similar. Whatever we do we are confirming our place in the human experience.

Jane Austen had the genius and confidence to capture the essence of this human experience. With an economy of words that a poet might envy she could state that 'it was a delightful visit; perfect in being much too short'. No explanation is needed – we recognize immediately the exactness of the statement, and its wider implications. But Austen was never didactic. She made her point in her typical fashion, with the light, mocking, slightly tongue-in-cheek tone that speaks directly to the reader.

There are many subjects not to be found in Jane Austen's novels – death, childbirth, real poverty and violence are just some – but that isn't to say she didn't know about them. She just chose not to write about them; they had no place in the type of book she wanted to produce. Her own experiences underpinned everything she wrote, and because she *did* know people so thoroughly, we are left, after reading her tales of love and marriage, with a deep-seated impression of having penetrated some of the mysteries of life.

...we are all apt to expect too much...

Mansfield Park

One man's ways may be as good as another's, but we all like our own best.

Persuasion

That is the case with all of us, Papa. One half of the world cannot understand the pleasures of the other.

Emma

...if one scheme of happiness fails, human nature turns to another...

Mansfield Park

How quick come the reasons for approving what we like.

Persuasion

The Human Experience

Seldom, very seldom, does complete truth belong to any human disclosure; seldom can it happen that something is not a little disguised, or a little mistaken...

Emma

...left her only just so much solicitude as the human mind can never do comfortably without.

Northanger Abbey

...there are some situations of the human mind in which good sense has very little power...

Northanger Abbey

You should never fret about trifles.

Northanger Abbey

It will be a bitter pill to her; that is, like other bitter pills, it will have two moments ill-flavour, and then be swallowed and forgotten...

Mansfield Park

...a loss may be sometimes a gain.

Northanger Abbey

Are no probabilities to be accepted merely because they are not certainties?

Sense and Sensibility

...all those little matters on which the daily happiness of private life depends...

Emma

...storms and sleeplessness are nothing when they are over.

Northanger Abbey

...tossed about in her bed, and envied every quiet sleeper.

Northanger Abbey

...the comfort of ease and familiarity would come in time.

Pride and Prejudice

What so natural, as that anger should pass away and repentance succeed it?

Northanger Abbey

To be a second time disappointed in the same way was an instance of very severe ill-luck...

Mansfield Park

Every body has their taste in noises as well as in other matters; and sounds are quite innoxious, or most distressing, by their sort rather than their quantity.

Persuasion

...missed as every noisy evil is missed when it is taken away; that is, there is a great difference felt.

Mansfield Park

...after all that romancers may say, there is no doing without money.

Northanger Abbey

...people always live for ever when there is any annuity to be paid them.

Sense and Sensibility

...it is poverty only which makes celibacy contemptible to a generous public! A single woman, with a very narrow income, must be a ridiculous, disagreeable, old maid! the proper sport of boys and girls; but a single woman, of good fortune, is always respectable, and may be as sensible and pleasant as anybody else. And the distinction is not quite so much against the candour and common sense of the world as appears at first; for a very narrow income has a tendency to contract the mind, and sour the temper. Those who can barely live, and who live perforce in a very small, and generally very inferior, society, may well be illiberal and cross.

Emma

One cannot creep upon a journey; one cannot help getting on faster than one had planned; and the pleasure of coming in upon one's friends before the look-out begins, is worth a great deal more than any little exertion it needs.

Emma

...a removal from one set of people to another, though at a distance of only three miles, will often include a total change of conversation, opinion, and idea.

Persuasion

The Human Experience

It was a delightful visit; – perfect, in being much too short.

Emma

...the pain of parting from friends will be felt by every body at times...

Sense and Sensibility

...the art of knowing our own nothingness beyond our own circle...

Persuasion

It is not time or opportunity that is to determine intimacy; – it is disposition alone. Seven years would be insufficient to make some people acquainted with each other, and seven days are more than enough for others.

Sense and Sensibility

...there was all the pain of apprehension frequently to be endured, though the offence came not.

Emma

...now found the difference between the expectation of an unpleasant event, however certain the mind may be told to consider it, and certainly itself.

Sense and Sensibility

...she found, what has been sometimes found before, that an event to which she had looked forward with impatient desire, did not in taking place, bring all the satisfaction she had promised herself.

Pride and Prejudice

A scheme of which every part promises delight, can never be successful; and general disappointment is only warded off by the defence of some little peculiar vexation.

Pride and Prejudice

...that best of blessings, an escape from many certain evils...

Mansfield Park

...where the mind is any thing short of perfect decision, an adviser may, in an unlucky moment, lead it to do what it may afterwards regret.

Mansfield Park

The Human Experience

...where other powers of entertainment are wanting, the true philosopher will derive benefit from such as are given.

Pride and Prejudice

...such a contrast... as time is forever producing between the plans and decisions of mortals, for their own instruction, and their neighbours' entertainment.

Mansfield Park

...for what do we live, but to make sport for our neighbours, and laugh at them in our turn?

Pride and Prejudice

First published in 1997 by Pavilion

This edition published in 2021 by
Portico
43 Great Ormond Street
London, WC1N 3HZ

An imprint of Pavilion Books Company Ltd

ISBN 978-1-911622-69-7

A CIP catalogue record for this book is available from the British Library.

10 9 8 7 6 5 4 3 2 1

Reproduction by Rival Colour Ltd, UK
Printed and bound by Toppan Leefung Ltd, China

www.pavilionbooks.com

Publisher: Helen Lewis
Commissioning Editor: Lucy Smith
Designer: Alice Kennedy-Owen
Editor: Izzy Holton
Production Controller: Phil Brown